Goose Goes Shopping

白鵝小菇去購物

Laura Wall

新雅文化事業有限公司
www.sunya.com.hk

新雅·點讀樂園 *Goose*（白鵝小菇故事系列）

　　本系列共 6 冊，以貼近幼兒的語言，向孩子講述小女孩蘇菲與白鵝小菇的相遇和生活點滴。故事情節既輕鬆惹笑，又體現主角們彌足珍貴的友誼，能感動小讀者內心的柔軟，讓他們學懂發現生活中的小美好，做一個善良、溫柔的孩子。

　　此外，內文設有中、英雙語對照及四語點讀功能，包括英語、粵語書面語、粵語口語和普通話，能促進幼兒的語文能力發展。快來一起看蘇菲和小菇的暖心故事吧！

如何啟動新雅點讀筆的四語功能

　　請先檢查筆身編號：如筆身沒有編號或編號是 SY04C07、SY04D05，請先按以下步驟下載四語功能檔案並啟動四語功能；如編號第五個號碼是 E 或往後的字母，可直接閱讀下一頁，認識如何使用新雅閱讀筆。

1. 瀏覽新雅網頁 (www.sunya.com.hk) 或掃描右邊的 QR code 進入 新雅·點讀樂園 。

2. 點選 下載點讀筆檔案 ▶ 。

3. 依照下載區的步驟說明，點選及下載 *Goose*（白鵝小菇故事系列）框目下的四語功能檔案「update.upd」至電腦。

4. 使用 USB 連接線將點讀筆連結至電腦，開啟「抽取式磁碟」，並把四語功能檔案「update.upd」複製至點讀筆的根目錄。

5. 完成後，拔除 USB 連接線，請先不要按開機鍵。

6. 把點讀筆垂直點在白紙上，長按開機鍵，會聽到點讀筆「開始」的聲音，注意在此期間筆頭不能離開白紙，直至聽到「I'm fine, thank you.」，才代表成功啟動四語功能。

7. 如果沒有聽到點讀筆的回應，請重複以上步驟。

如何使用新雅點讀筆閱讀故事？

1. 下載本故事系列的點讀筆檔案

1️⃣ 瀏覽新雅網頁 (www.sunya.com.hk) 或掃描右邊的 QR code 進入 新雅‧點讀樂園 。

2️⃣ 點選 下載點讀筆檔案 ▶ 。

3️⃣ 依照下載區的步驟說明，點選及下載 *Goose*（白鵝小菇故事系列）的點讀筆檔案至電腦，並複製至新雅點讀筆的「BOOKS」資料夾內。

2. 啟動點讀功能

開啟點讀筆後，請點選封面右上角的 新雅‧點讀樂園 圖示，然後便可翻開書本，點選書本上的故事文字或圖畫，點讀筆便會播放相應的內容。

3. 選擇語言

如想切換播放語言，請點選內頁左上角的 ENG 粵 ☆ 普 圖示，當再次點選內頁時，點讀筆便會使用所選的語言播放點選的內容。

4. 播放整個故事

如想播放整個故事，請直接點選以下圖示：

5. 製作獨一無二的點讀故事書

爸媽和孩子可以各自點選以下圖示，錄下自己的聲音來說故事！

1️⃣ 先點選圖示上 爸媽錄音 或 孩子錄音 的位置，再點 OK，便可錄音。

2️⃣ 完成錄音後，請再次點選 OK，停止錄音。

3️⃣ 最後點選 ▶ 的位置，便可播放錄音了！

4️⃣ 如想再次錄音，請重複以上步驟。注意每次只保留最後一次的錄音。

爸媽請使用這個圖示錄音

孩子請使用這個圖示錄音

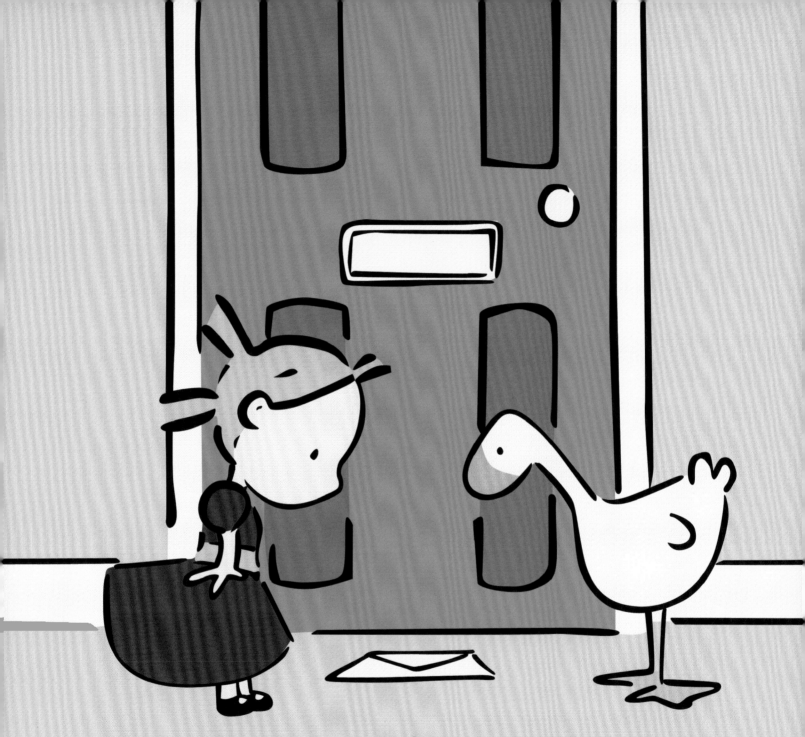

An envelope arrives for Sophie and Goose.

蘇菲和白鵝小菇收到一封信。

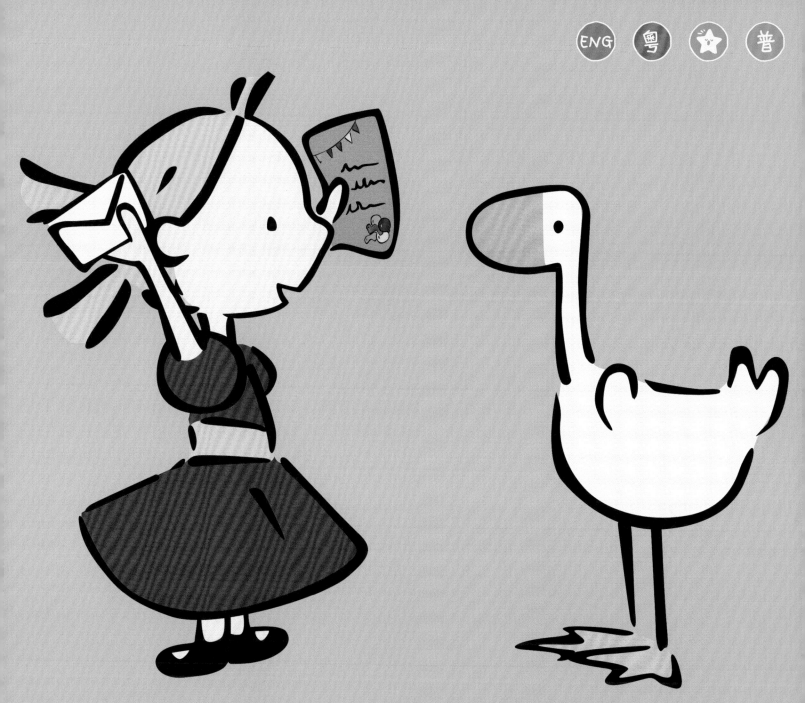

It's an invitation to Ben and Sam's party.

原來是邀請他們去參加阿賓和阿森的派對。

5

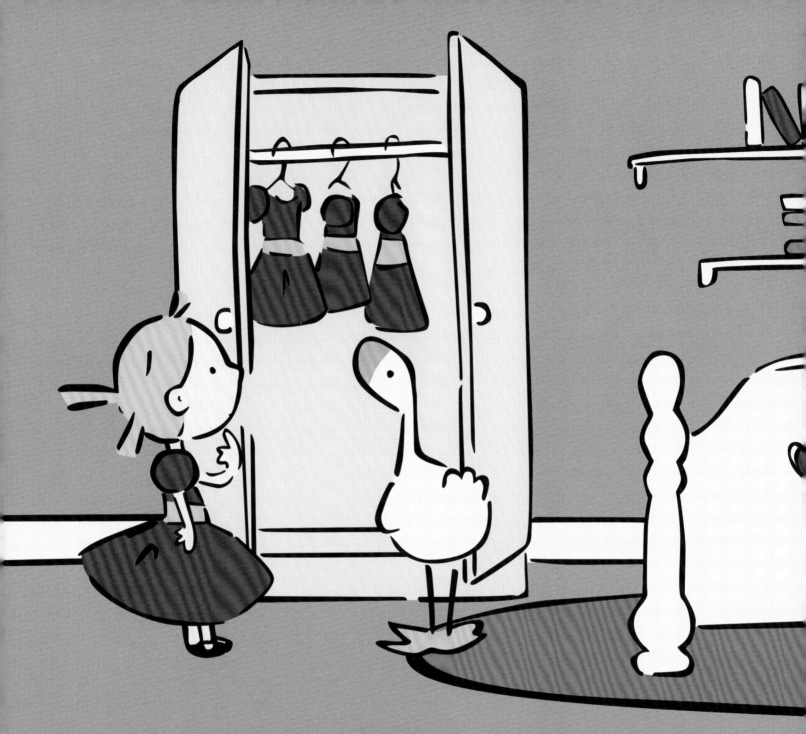

But Sophie has no party clothes to wear.

但蘇菲沒有出席派對的服裝。

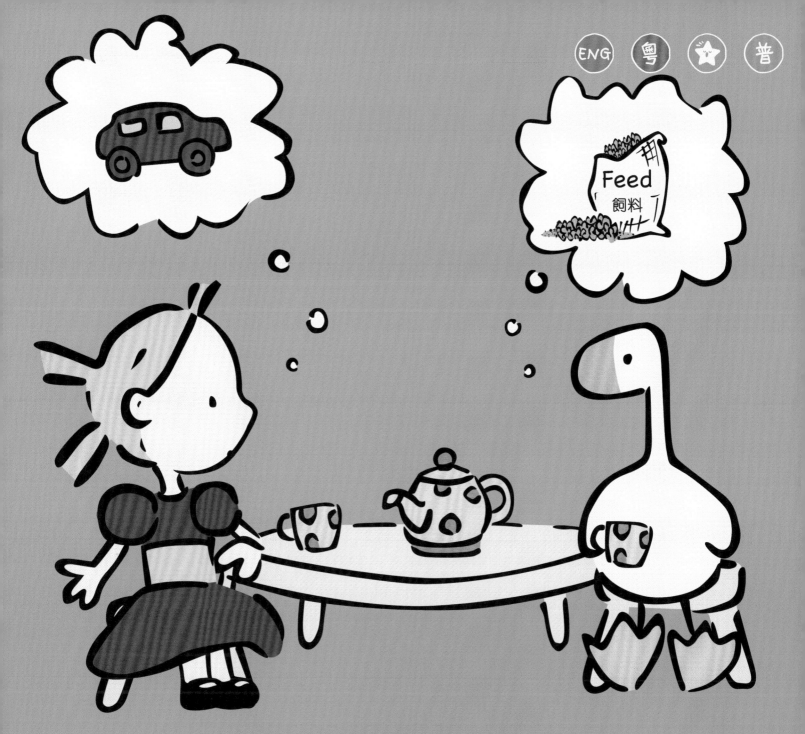

Or presents to give.

也沒有禮物可以送。

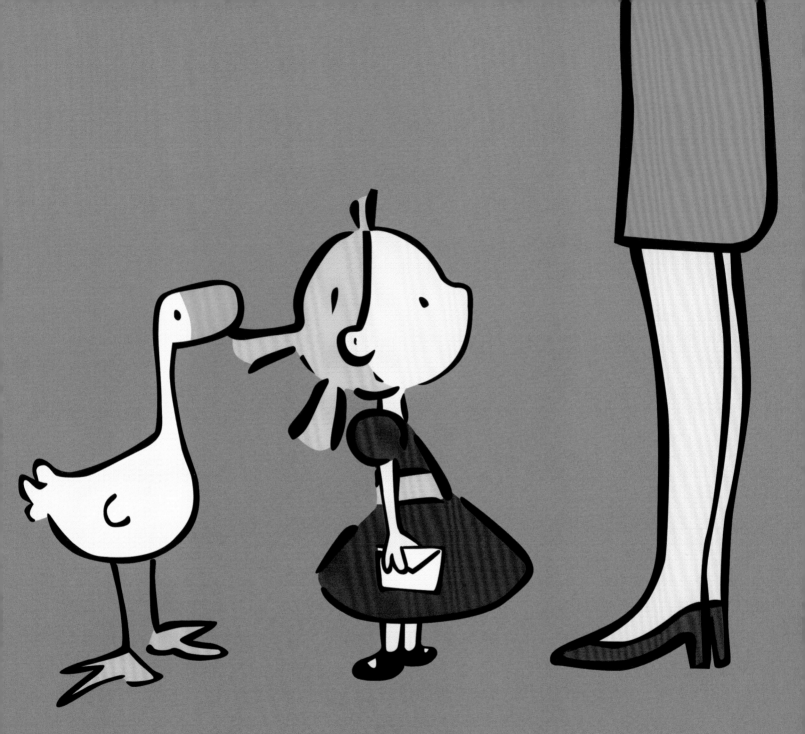

"We'll have to go to the shops," says Mum.
「我們到商店購物吧。」媽媽說。

Goose has never been to the shops.

小菇從來沒去過商店。

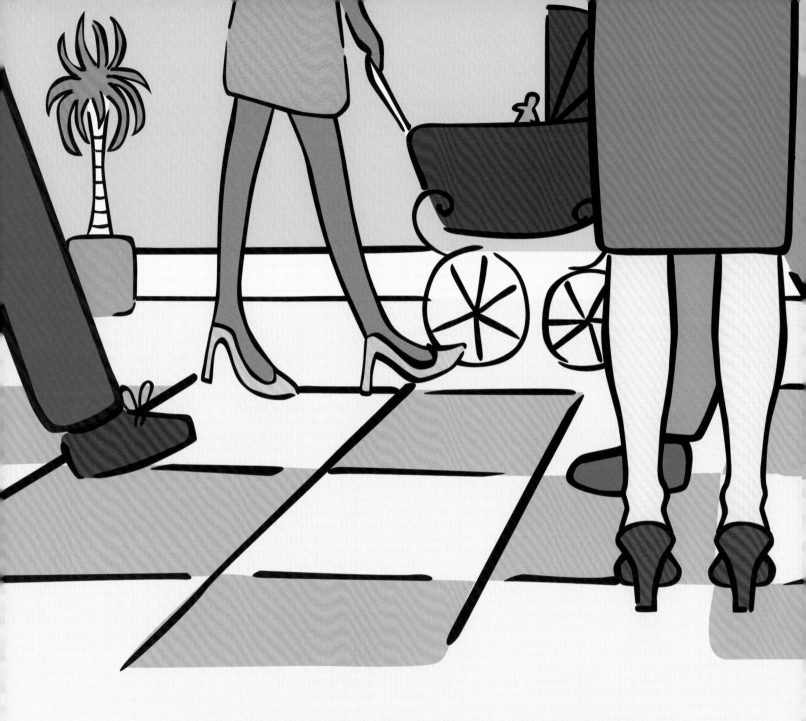

The shopping centre is very busy.

商場裏人來人往。

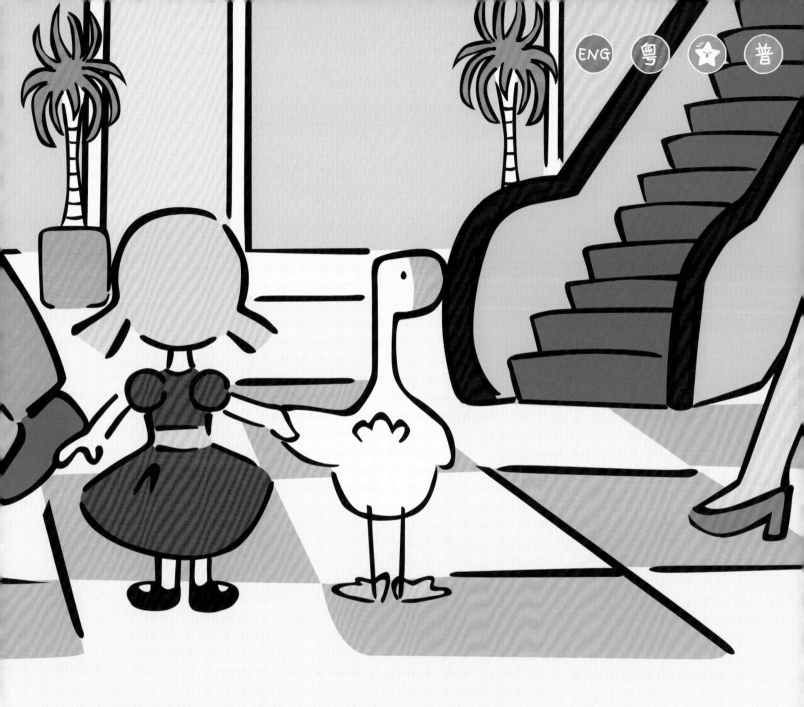

Goose spots a strange moving staircase.

小菇注意到有一條奇怪、會動的樓梯。

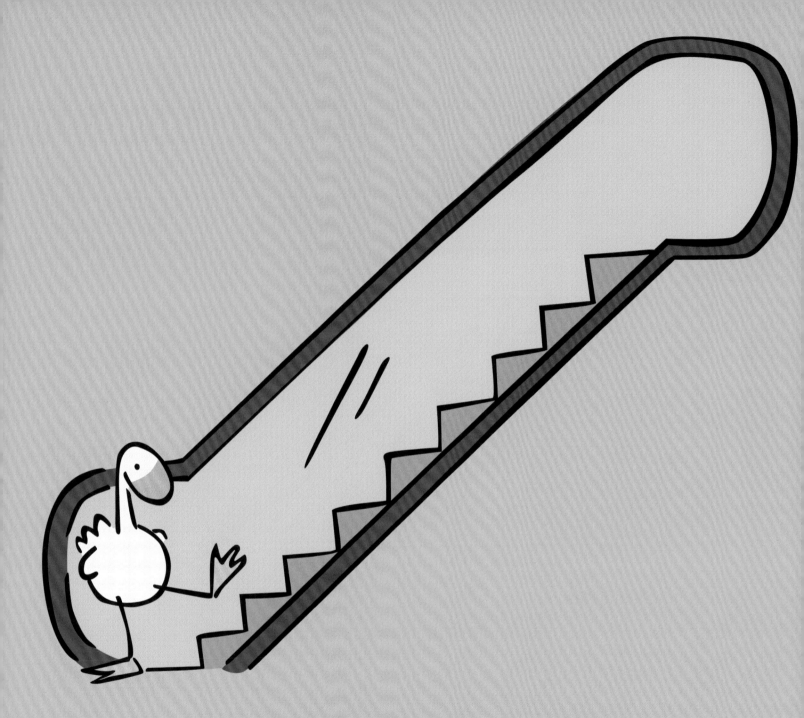

And he puts a flappy foot on it.

於是他啪噠啪噠地踩上去。

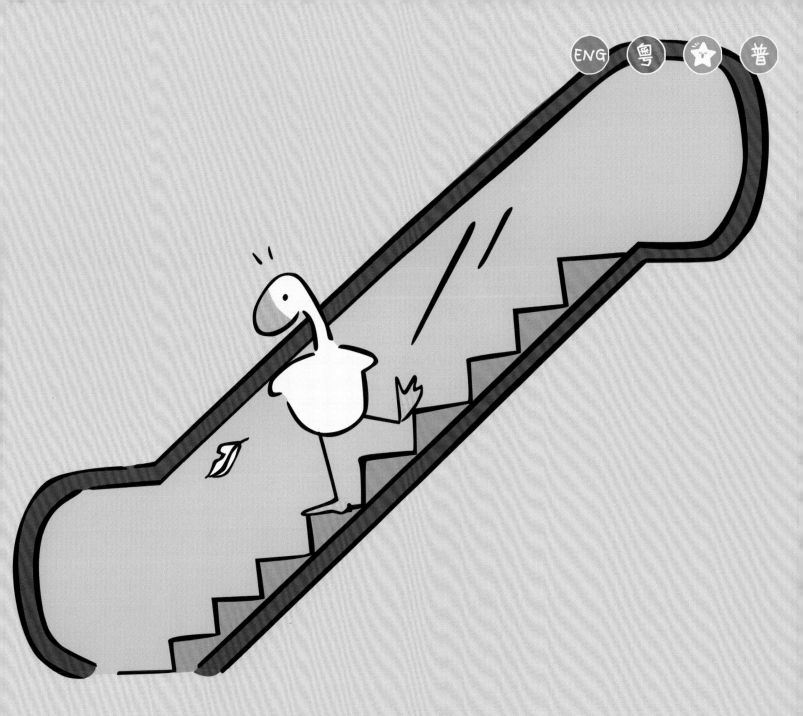

Whooosh! Goose is whisked upwards.

嗖——！樓梯帶着小菇快速地往上升。

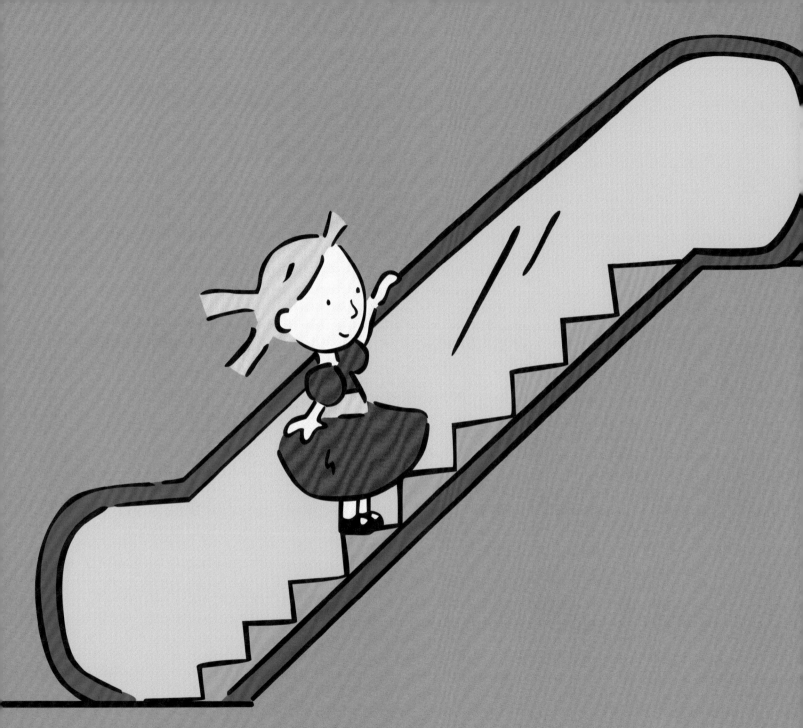

As Sophie follows Goose up one side...

蘇菲跟着小菇上了扶手電梯⋯⋯

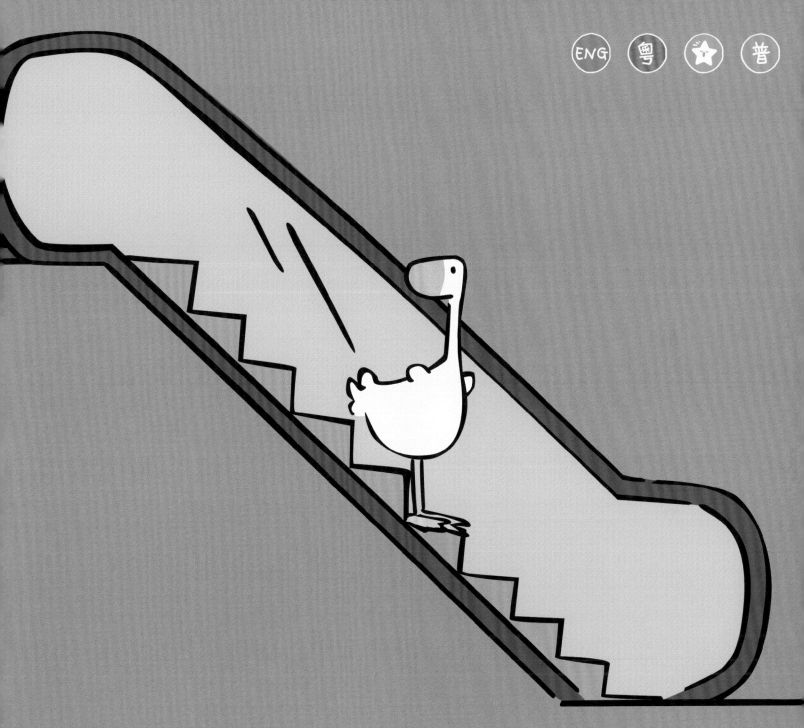

... he comes down the other!

小菇卻從另一邊下來了！

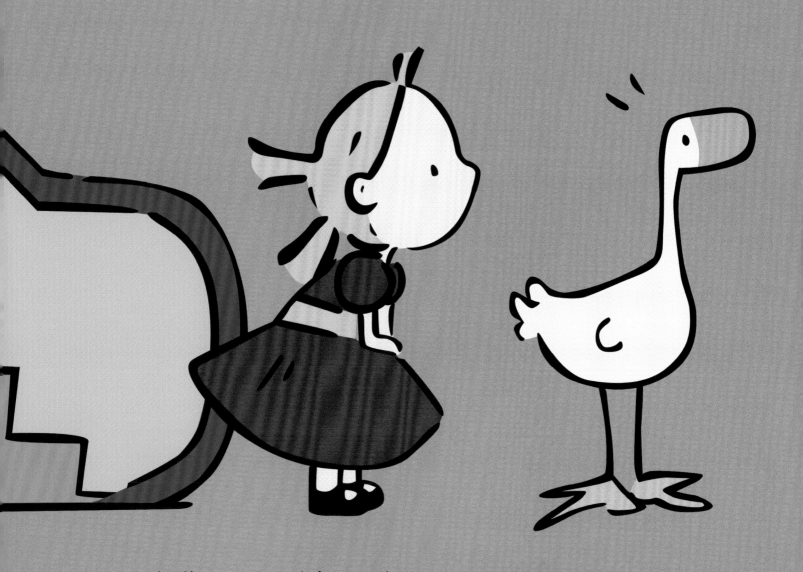

When Sophie catches up with Goose,

當蘇菲趕上小菇時，

they spot something that looks like fun.

他們注意到一個看來很好玩的東西。

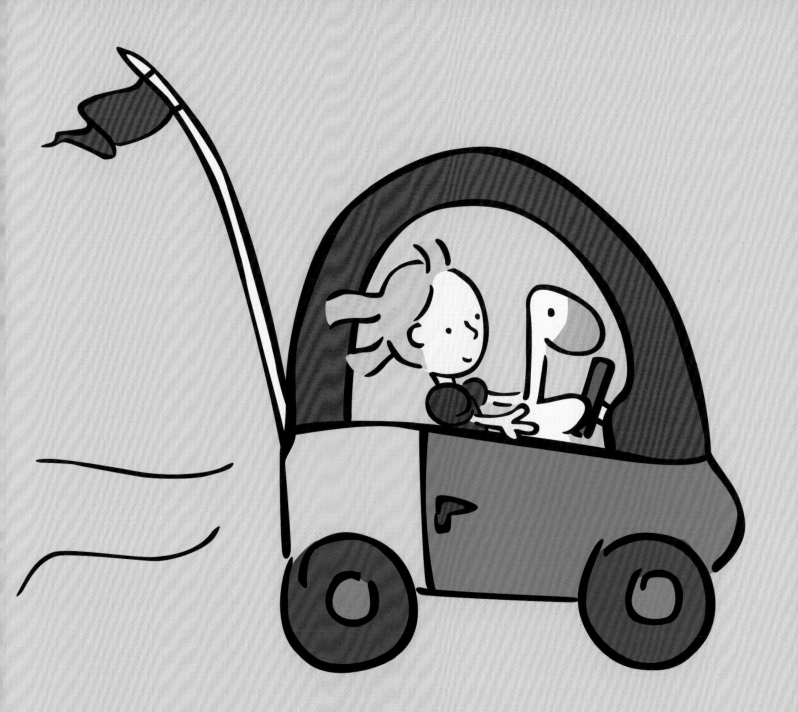

Wheeeeeeee!

嘩——！

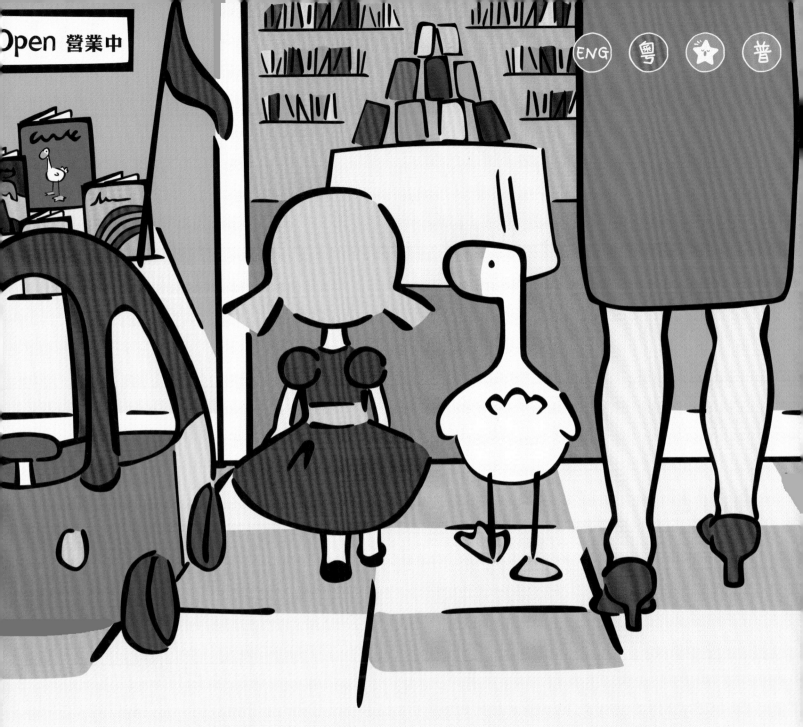

Mum, Sophie and Goose go into a bookshop.

媽媽、蘇菲和小菇走進了一家書店。

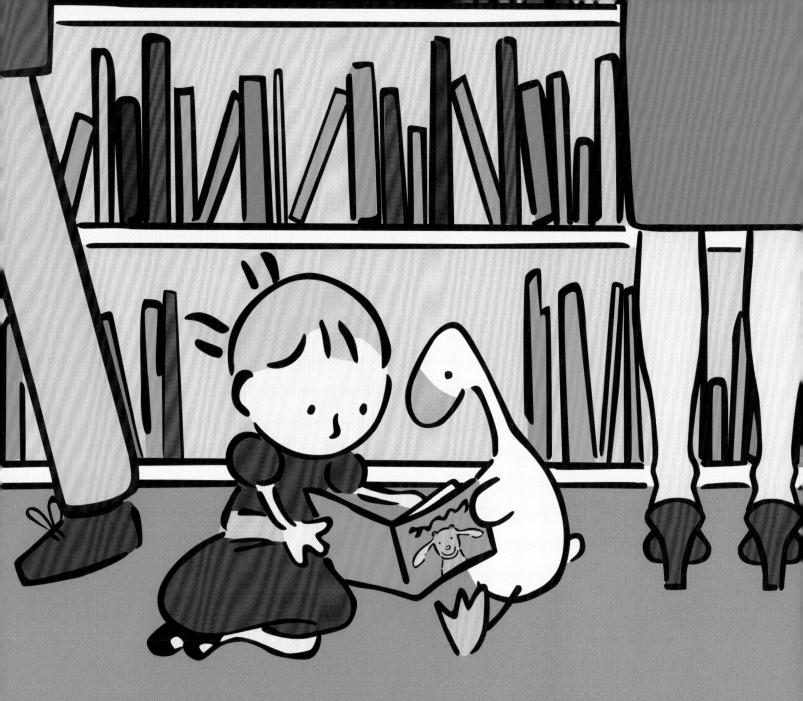

Sophie and Goose find a great gift for Ben.

蘇菲和小菇為阿賓挑選了一份很棒的禮物。

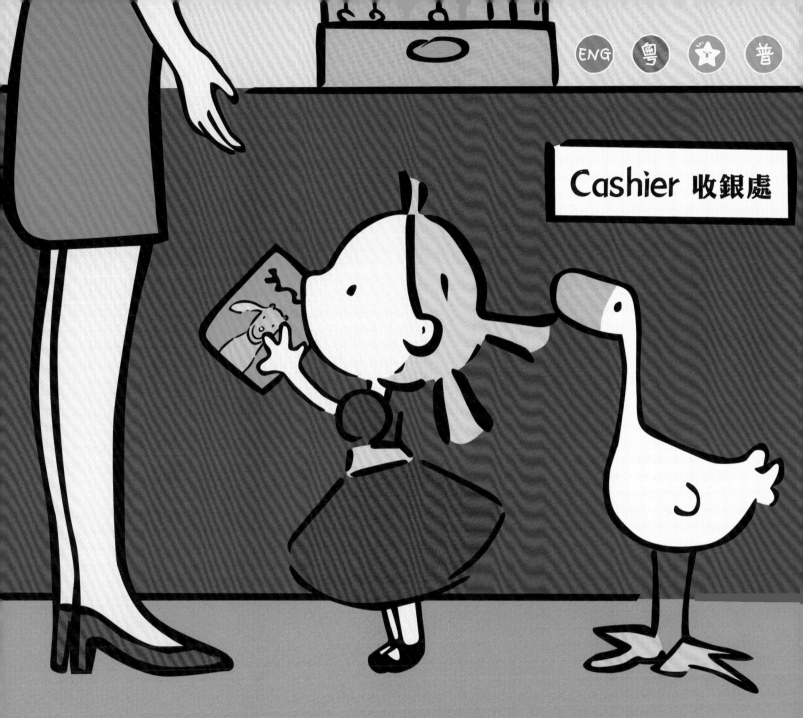

ENG 粵 ⭐ 普

Cashier 收銀處

"Now let's have some lunch," says Mum.

「現在我們一起去吃午餐吧！」媽媽說。

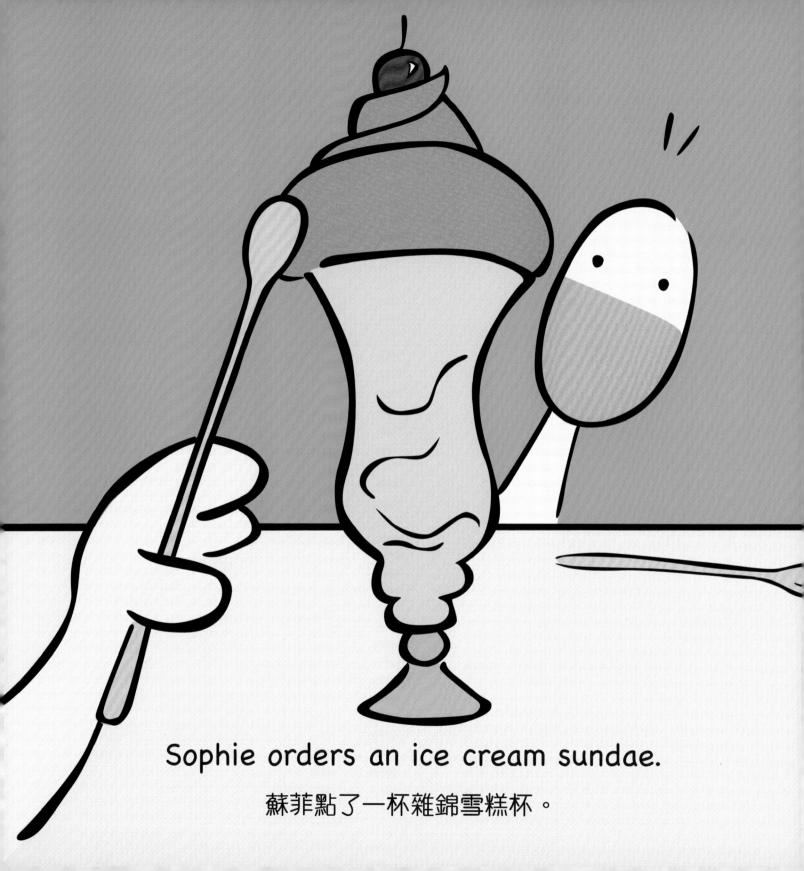

Sophie orders an ice cream sundae.

蘇菲點了一杯雜錦雪糕杯。

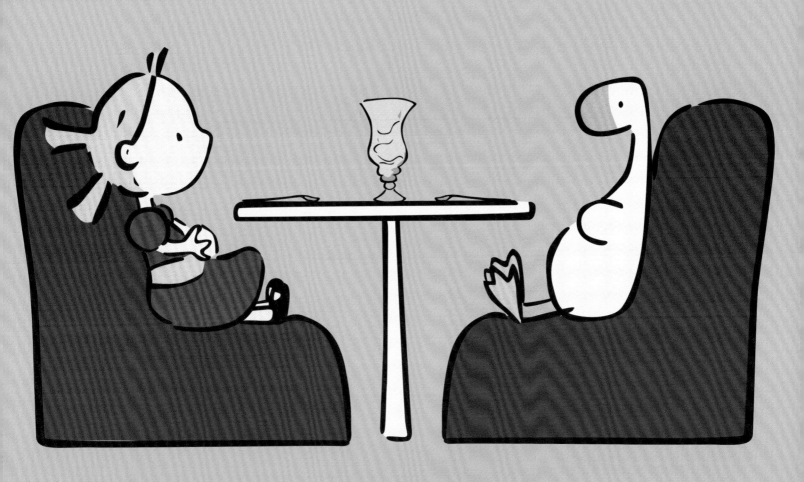

She shares it with Goose.
They both think it is very yummy indeed.

她和小菇一起分享。
他們倆都覺得這甜品真的很好吃。

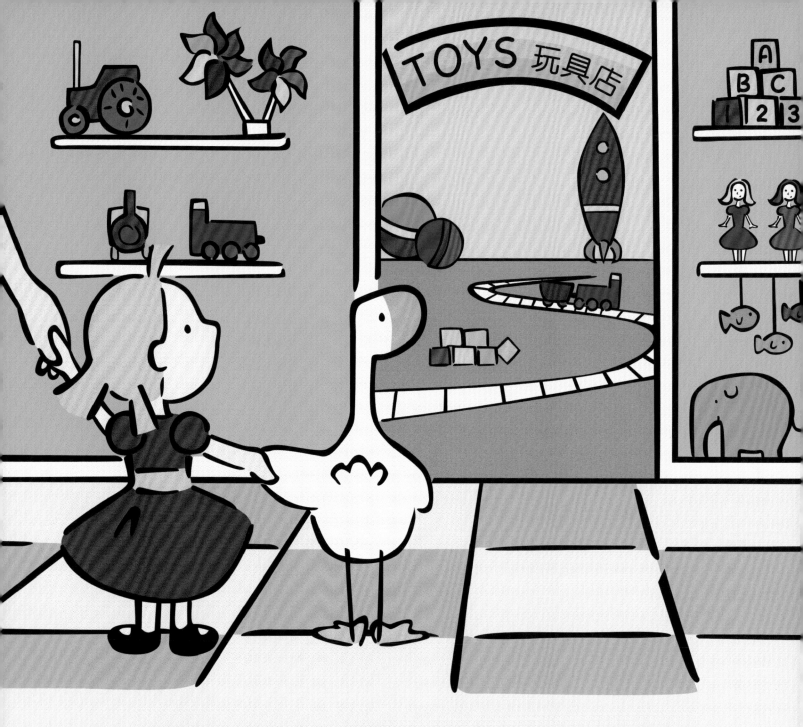

After lunch, they visit the toy shop.

午餐後，他們去逛玩具店。

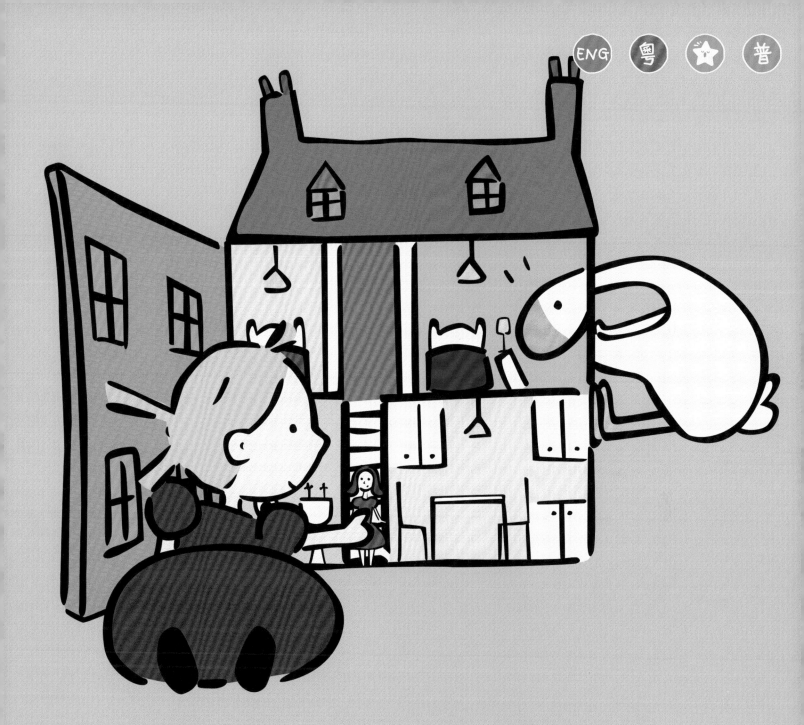

Sophie finds a lovely pink doll's house.

蘇菲發現了一間很可愛、粉紅色的玩具屋。

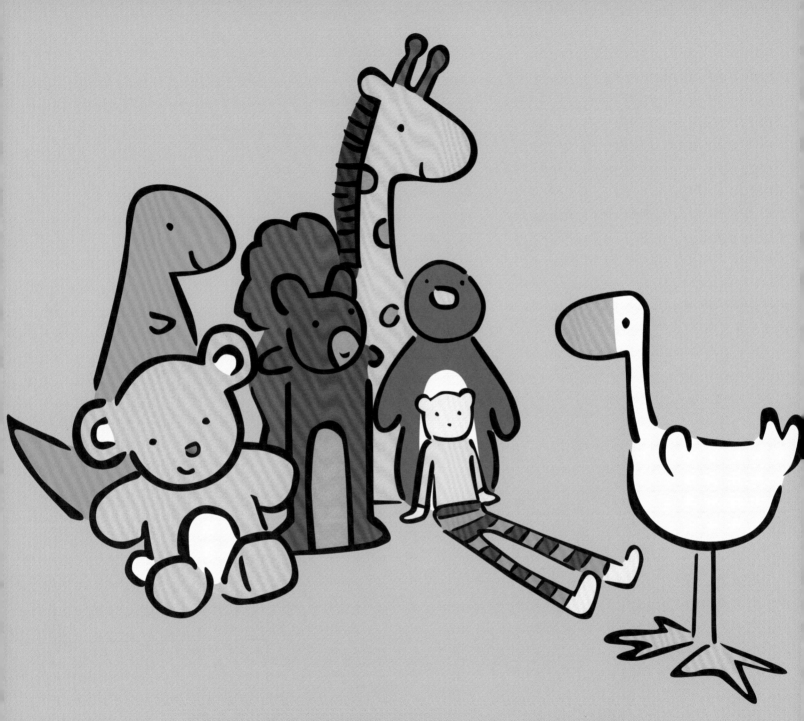

And Goose makes some friends.

而小菇則結交了幾位新朋友。

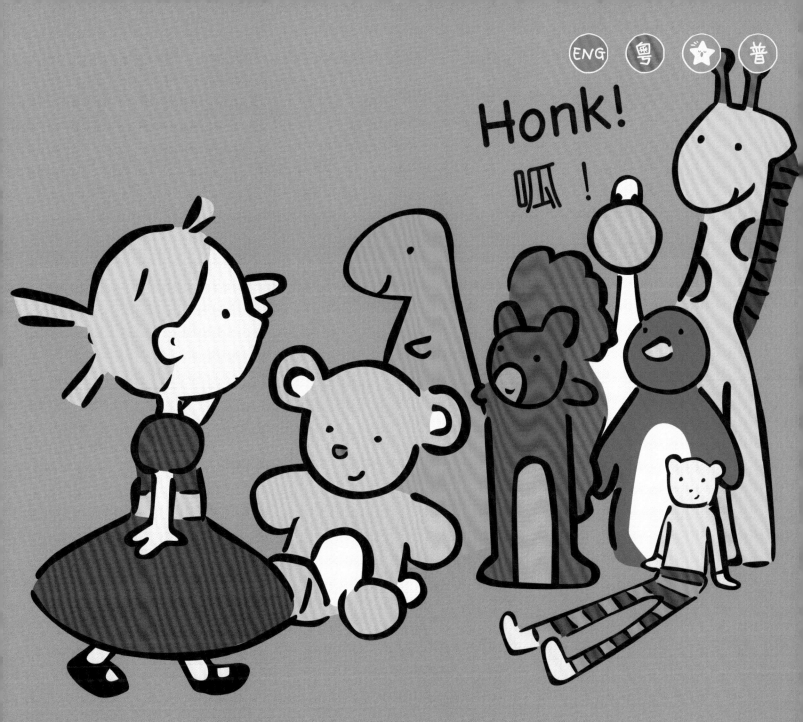

"Goose, where are you?"

「小菇，你在哪裏？」

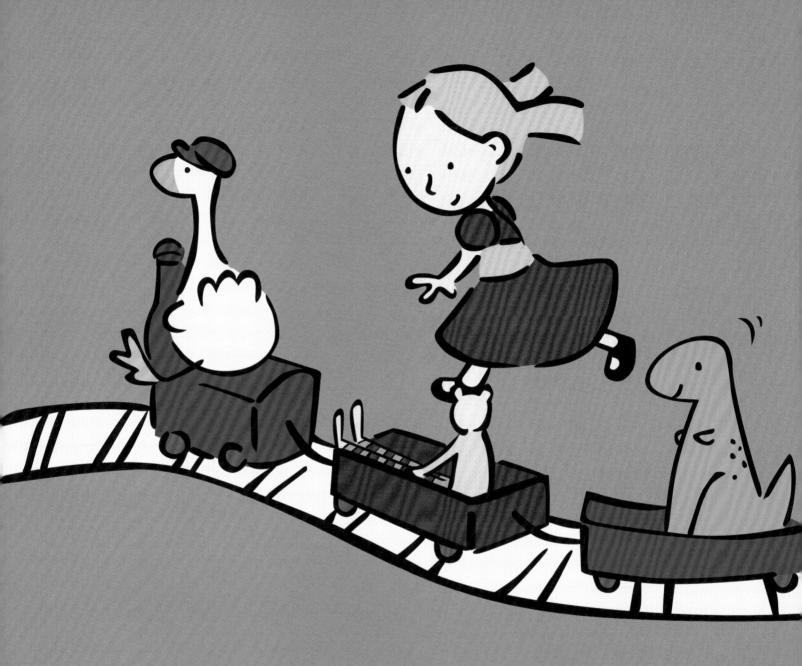

Sophie and Goose take their new friends

蘇菲和小菇帶着他們的新朋友，

 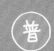

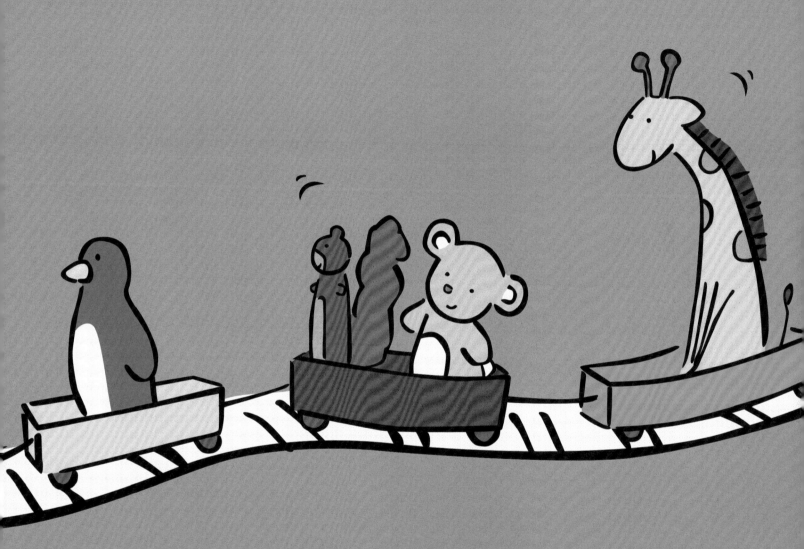

on a train ride round the toy shop.

坐上玩具火車環遊玩具店。

And they all enjoy watching the pretty toy
ferris wheel go round and round.

而且他們都喜歡看着漂亮的玩具摩天輪不停地轉啊轉。

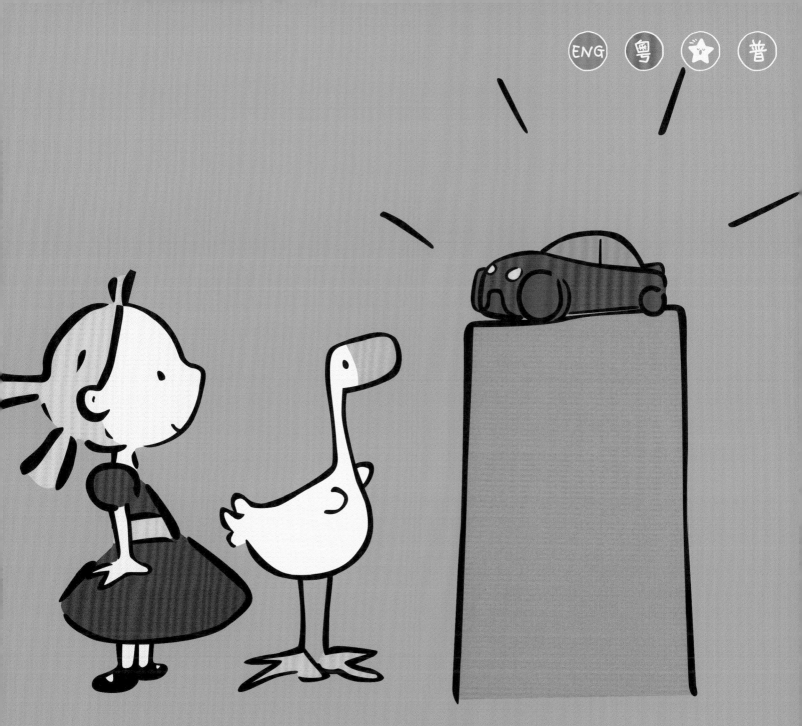

Then Goose finds a brilliant gift for Sam.

然後小菇為阿森找到一份很棒的禮物。

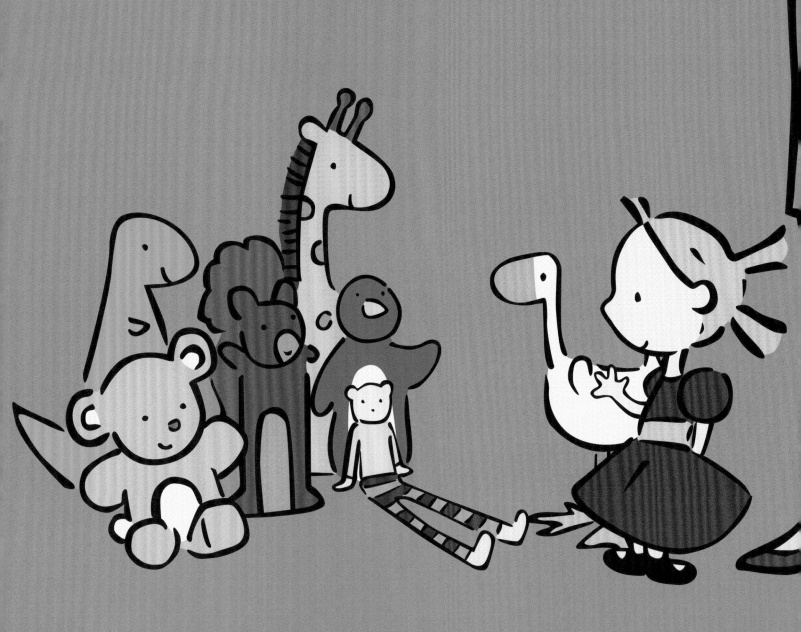

Now it's time to buy Sophie a party outfit.

現在，是時候為蘇菲買派對服裝了。

 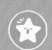

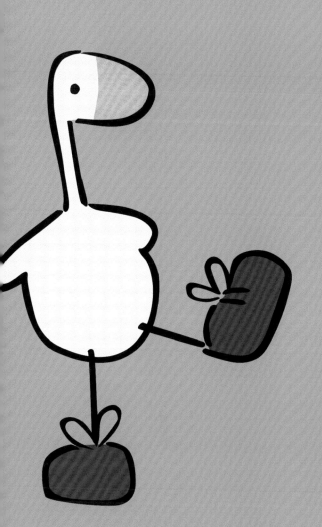

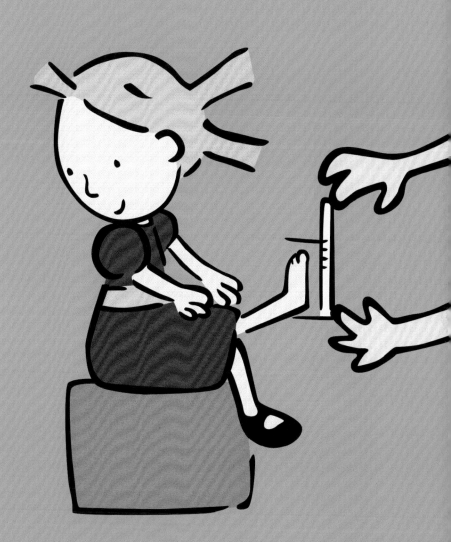

First, Sophie needs some new shoes.

首先，蘇菲需要一雙新鞋。

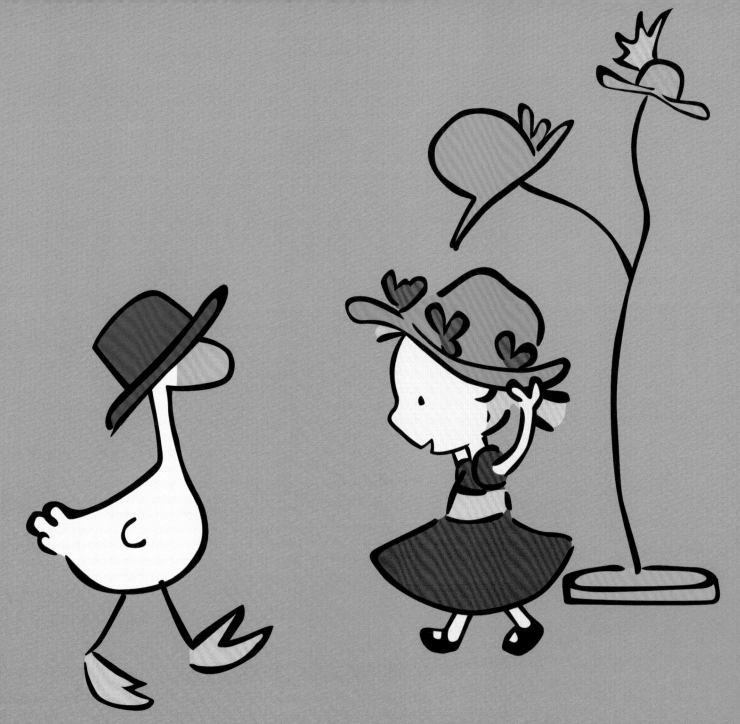

They find some nice hats, too.

他們還找到一些漂亮的帽子。

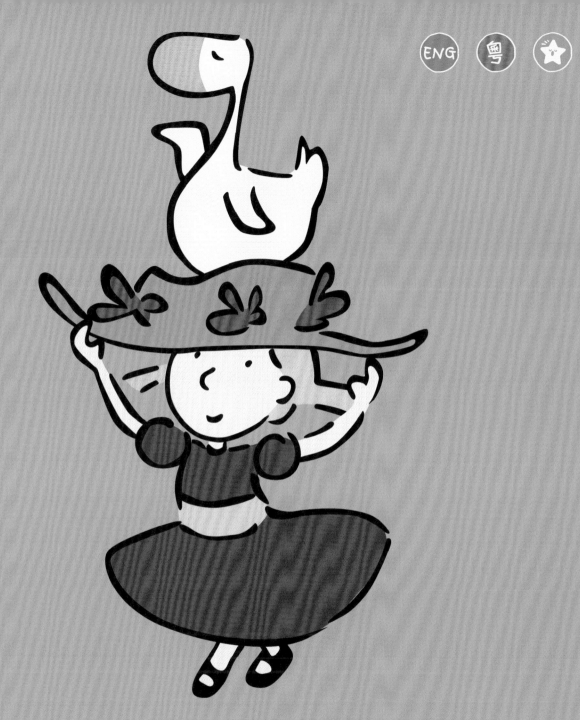

"Oh, Goose! What a lovely hat!"

「啊，小菇！這頂帽子真好看！」

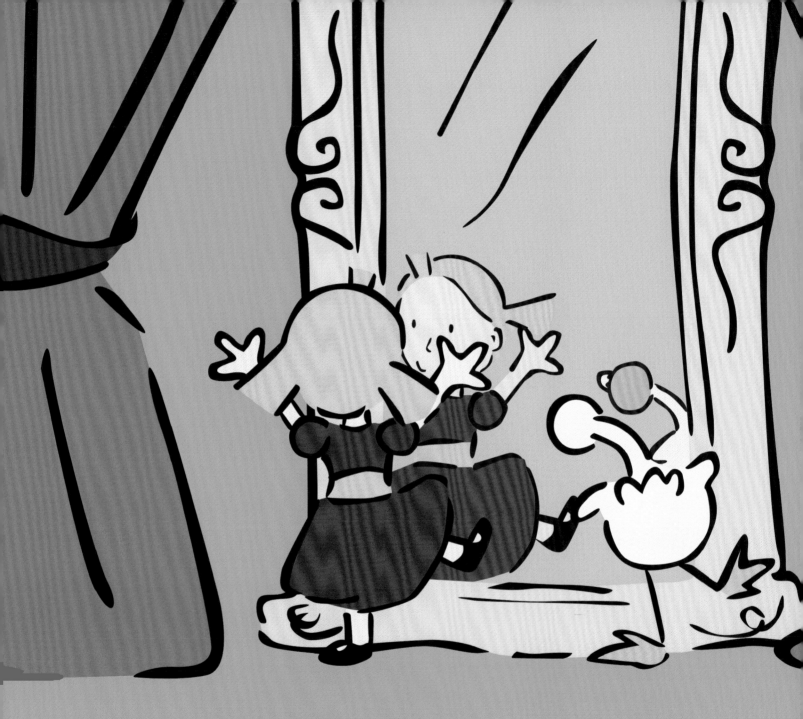

Then they make silly faces in a big mirror.

然後他們對着一面大鏡子扮鬼臉。

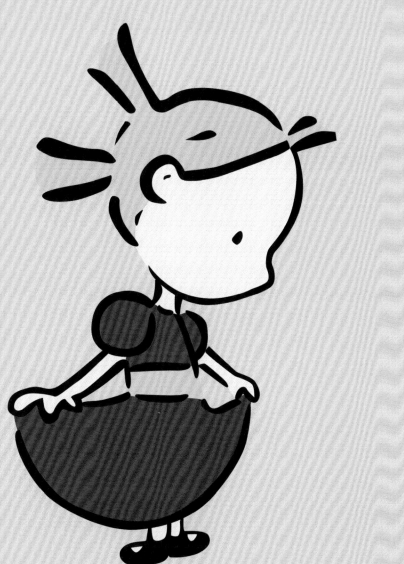
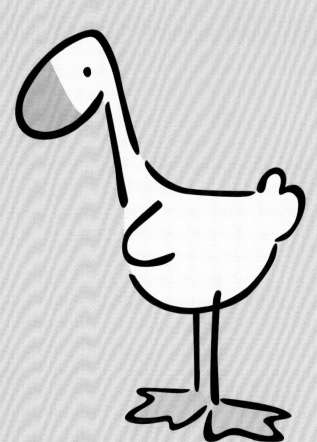

But Sophie still needs to find a new dress.

但蘇菲仍然需要找一條新裙子。

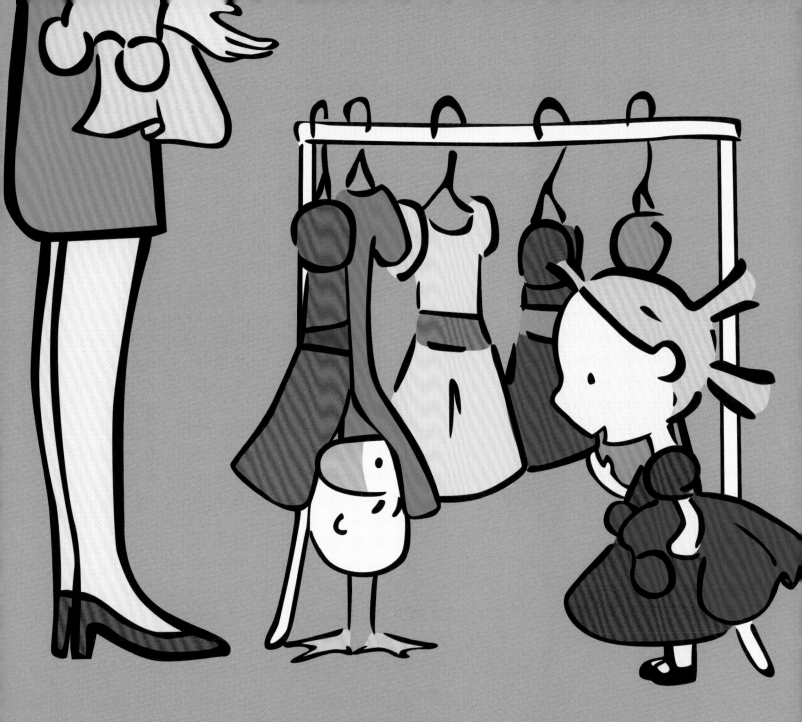

Mum and Sophie pick out a few to try on.

媽媽和蘇菲一起挑選了幾條裙子來試試看。

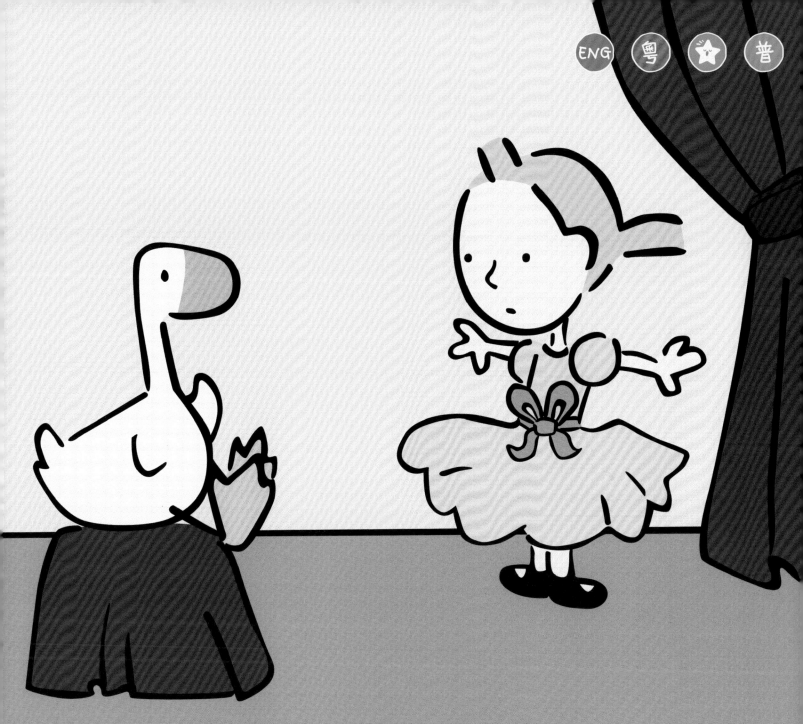

Sophie tries on a pink dress.

蘇菲試了一條粉紅色的裙子。

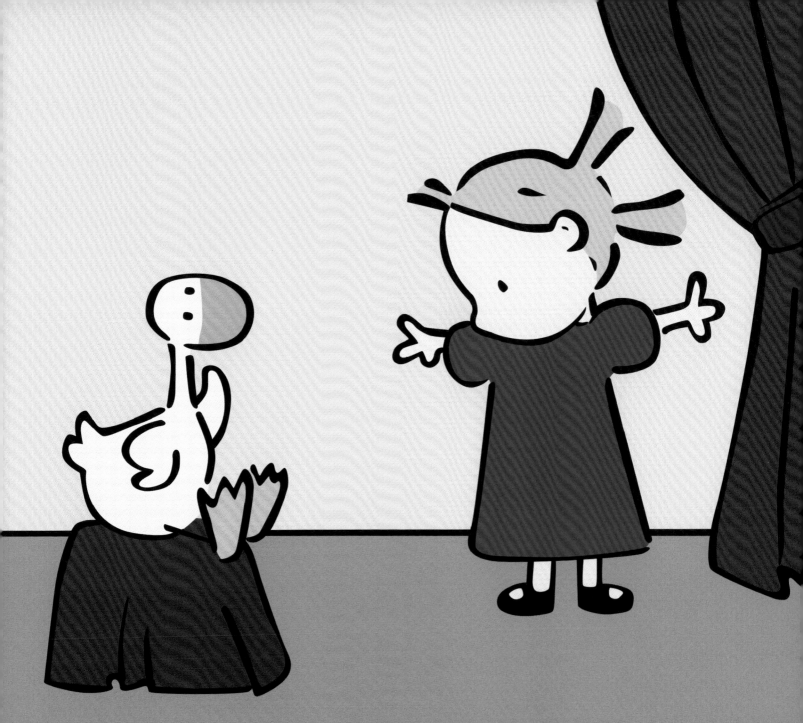

And then a blue one.

然後又試了一條藍色的裙子。

But none of them seem quite right. Until...

但似乎都不太合適。最終⋯⋯

Perfect!

完美！

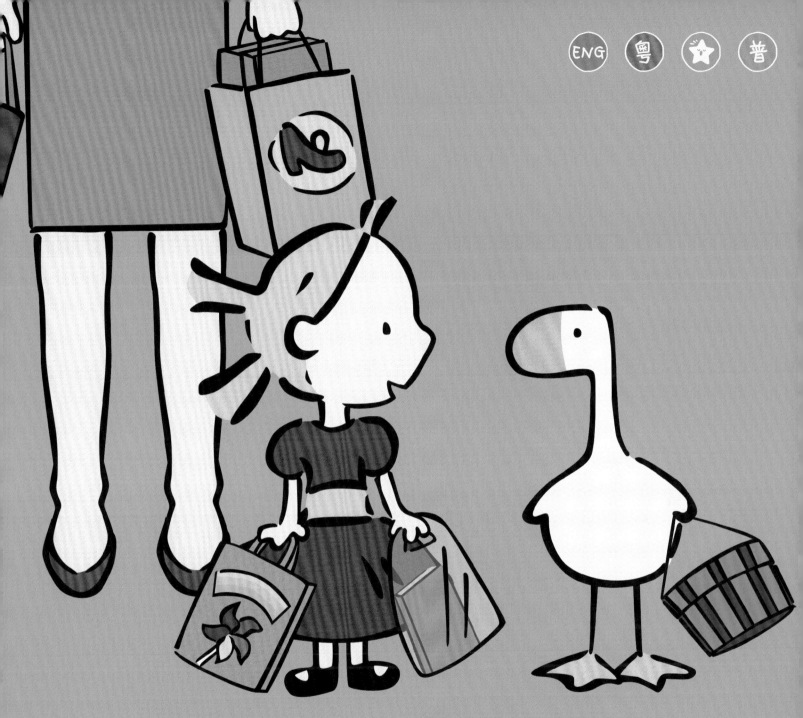

"It's time to go home," says Mum.

「是時候回家了。」媽媽說。

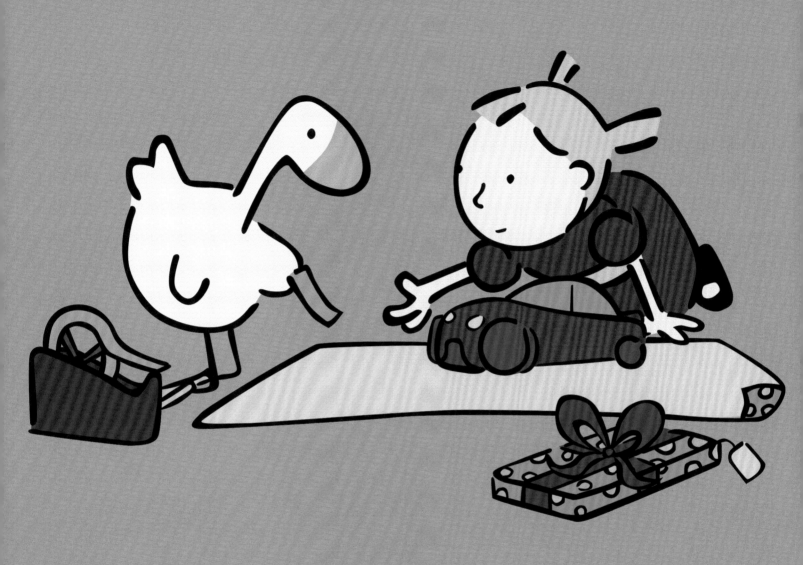

Goose helps Sophie to wrap the gifts
for Ben and Sam.

小菇幫蘇菲把送給阿賓和阿森的禮物包好。

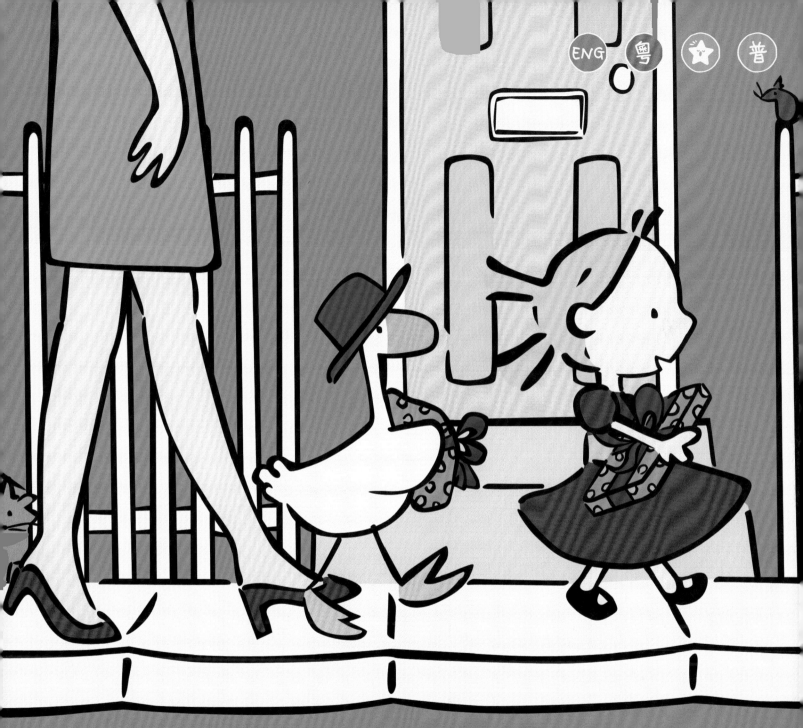

Excitedly they walk to the party with Mum.

他們興奮地跟媽媽一起走去參加派對。

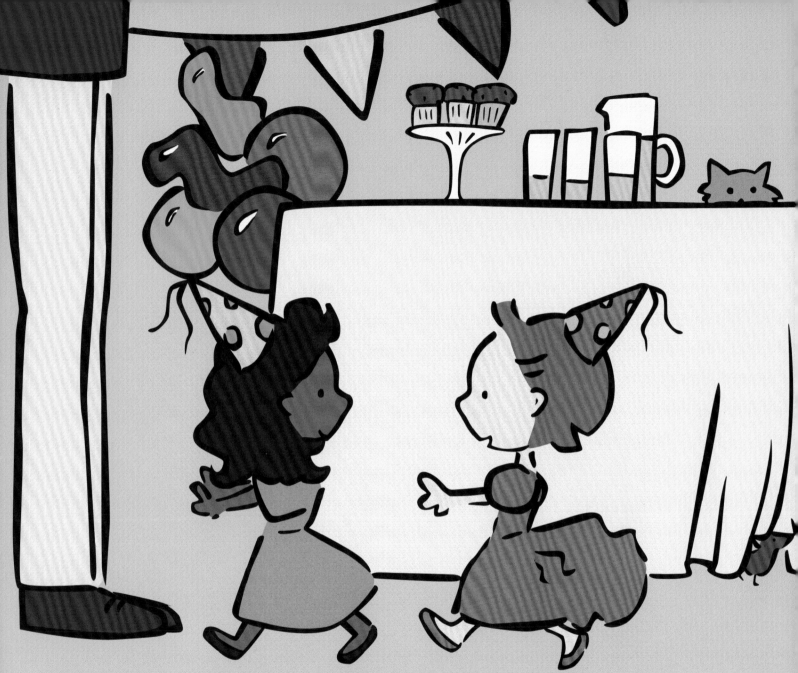

"We hope you like your presents! We had lots of fun choosing them, didn't we, Goose?"

「希望你們喜歡這些禮物！挑選禮物為我們帶來很多樂趣呢！對吧，小菇？」

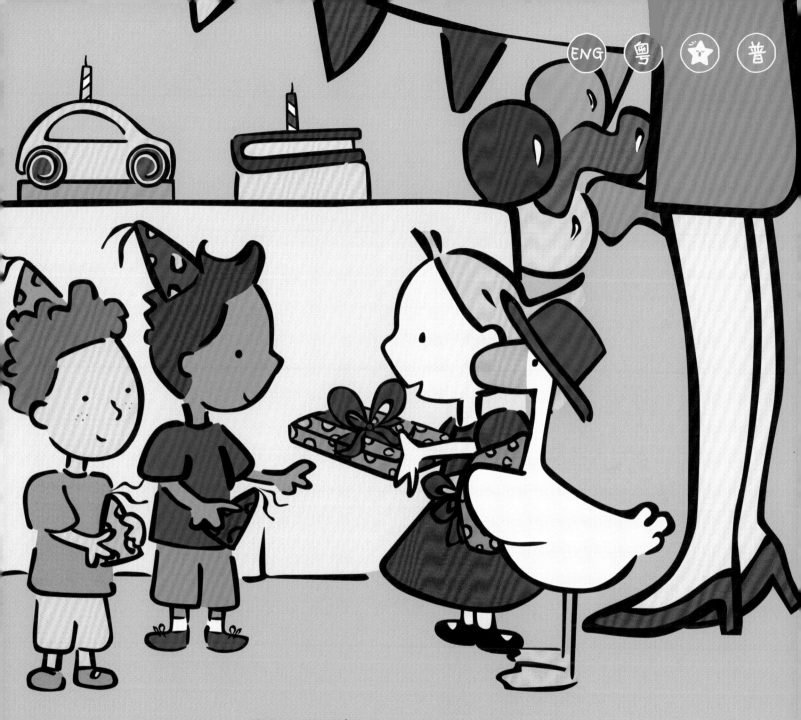

"Honk!" says Goose.

「呱！」小菇說。

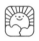

Goose 白鵝小菇故事系列
Goose Goes Shopping 白鵝小菇去購物

圖　　文：蘿拉·華爾（Laura Wall）
翻　　譯：潘心慧
責任編輯：黃偲雅
美術設計：張思婷
出　　版：新雅文化事業有限公司
　　　　　香港英皇道499號北角工業大廈18樓
　　　　　電話：（852）2138 7998
　　　　　傳真：（852）2597 4003
　　　　　網址：http://www.sunya.com.hk
　　　　　電郵：marketing@sunya.com.hk
發　　行：香港聯合書刊物流有限公司
　　　　　香港荃灣德士古道220-248號荃灣工業中心16樓
　　　　　電話：（852）2150 2100
　　　　　傳真：（852）2407 3062
　　　　　電郵：info@suplogistics.com.hk
印　　刷：中華商務彩色印刷有限公司
　　　　　香港新界大埔汀麗路36號
版　　次：二〇二三年五月初版

ISBN : 978-962-08-8164-0
Original published in English as 'Goose Goes Shopping'
© Award Publications Limited 2012
Traditional Chinese Edition © 2023 Sun Ya Publications (HK) Ltd.
18/F, North Point Industrial Building, 499 King's Road, Hong Kong
Published in Hong Kong SAR, China
Printed in China